LESSONS ON
SHADING

W. E. Sparkes

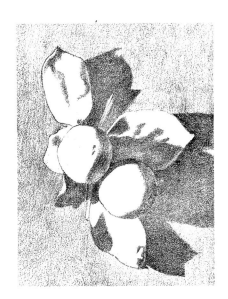

DOVER PUBLICATIONS, INC.
Mineola, New York

Bibliographical Note

This Dover edition, first published in 2007, is an unabridged republication of *How to Shade from Models, Common Objects, and Casts of Ornament,* originally published by Cassell and Company, Limited, London, 1900.

Library of Congress Cataloging-in-Publication Data

Sparkes, W. E.
 [How to shade from models, common objects, and casts of ornament]
 Lessons on shading / W.E. Sparkes.
 p. cm.
 Originally published: How to shade from models, common objects, and casts of ornament. London : Cassell, 1900.
 ISBN 0-486-45451-7 (pbk.)
 1. Shades and shadows in art. 2. Drawing—Technique. I. Title.

NC755.S63 2007
741.2—dc22

 2006052122

Manufactured in the United States of America
Dover Publications, Inc., 31 East 2nd Street, Mineola, N.Y. 11501

PREFACE.

WITH the introduction of shading among the require-
ments of the new " D " certificate, it became the duty
of the author to prepare a course of lectures for the
students under his tuition.

As the notes grew, he determined to put them in
a permanent form, feeling convinced that there existed
the want of a systematically arranged work on the
subject.

The experience gained in teaching Shading to
classes of pupil-teachers determined the form of the
work.

Starting from a few simple principles of light and
shade, the truth of which can be easily verified by
experiment, the subject is treated quite synthetic-
ally, so that the reader may from the beginning
take an intelligent interest in the work, and may be
able to account for all lights, shades, shadows, reflec-
tions, and gradations as they occur.

It is hoped that the book may also be found useful
to more advanced students ; for pains have been taken
to make it serviceable to those preparing finished
shaded works, or entering as candidates for the third
grade time-test examinations, as well as to that ever-
widening circle of readers who take up drawing as a
recreation.

CONTENTS.

CHAPTER I.

Introduction.

ALTHOUGH objects can be well represented on a flat surface by means of accurately drawn outlines, we find it impossible to express their solidity and the character of their surfaces without the addition of light and shade.

A circular plane and a sphere may each in some positions be rendered in outline by a circle ; a square plane and a cube by a square ; a cone and a sphere by a circle. Under such conditions the difference between the bodies can be expressed only by shading. These are, it is true, extreme cases ; but a moment's consideration will convince the student that mere outline can never adequately render the delicate variations of the surface of flowers and fruits.

All art is progressive, and is fostered only by careful and exact observation. To the beginner there is little to choose between a tree drawn in outline by Mr. Alfred Parsons, or a figure by Mr. Henry Holiday, and the characterless production of some amateur friend ; and only after much observation does the difference become apparent.

So the educated eye alone is fully alive to all the wonderful variety of light and shade in Nature—in clouds, hills, waves, fruits, trees, and leaves.

At first the reader will be unable to realise the gradations that he is assured are to be found on an object before him. But by carefully noting the well-defined differences of light and shade on geometrical solids, he will in time be able to

distinguish the more delicate ones on casts of ornament or on natural objects.

Lights, Shades, Shadows

Place a whitened india-rubber ball upon a dark book-cover, and in a stream of light falling in a direction from left to right of the spectator. (*See* Fig. 43.)

The surface of the ball appears to be broadly divided into two parts, of which the darker is said to be in *shade*, the other in *light*. Moreover, its opaque body deprives part of the book-cover of light : *i.e.*, it casts a shadow. In the following pages this distinction will be maintained. By *shadows* we shall always mean cast-shadows, and by *shades* those parts of the surface turned from the direct light.

Now place the ball upon a sheet of white paper, and you will see light, shade, and shadow as before ; but the shade appears considerably lighter in parts than before—a change due to light reflected from the paper.

This portion of the shade—for it is always most strongly marked in the shade—is known as the *reflected light*. It is always present, but is most evident when the reflecting body is light in tone.

Again, that spot on the left side of the egg lying directly opposite the source of light is decidedly brighter than any other part of that side.

This spot is said to be the *high light*, and the remaining portion is said to be in *half tone*.

Shadows (A) *cast by artificial light.*—The character of the shadows cast by artificial light can be best explained by a few simple experiments.

Take two sheets of cardboard and place them at right angles to one another, and in a flood of light *from a single source*. Then (as in Fig. 1) hold a smaller piece of cardboard with its faces parallel to the perpendicular sheet, so that its shadow may be caught upon the upright plane.

You will notice that the four points *a, b, c, d* are obtained by drawing lines from the source of light through the four

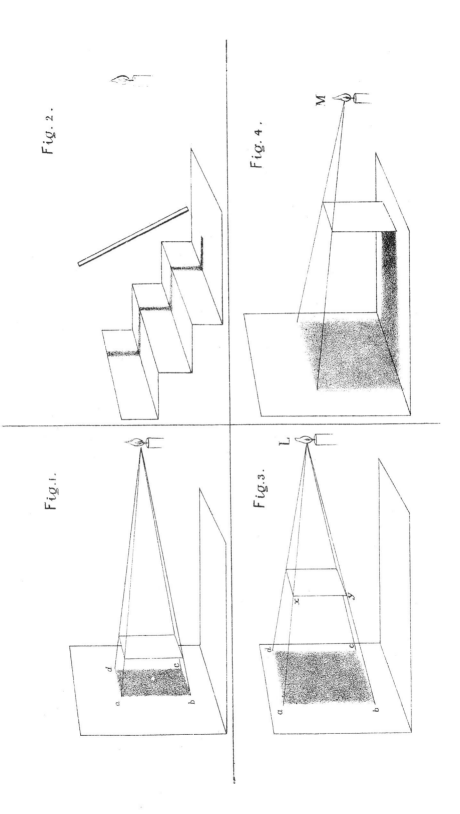

Fig. 1.

Fig. 2.

Fig. 3.

Fig. 4.

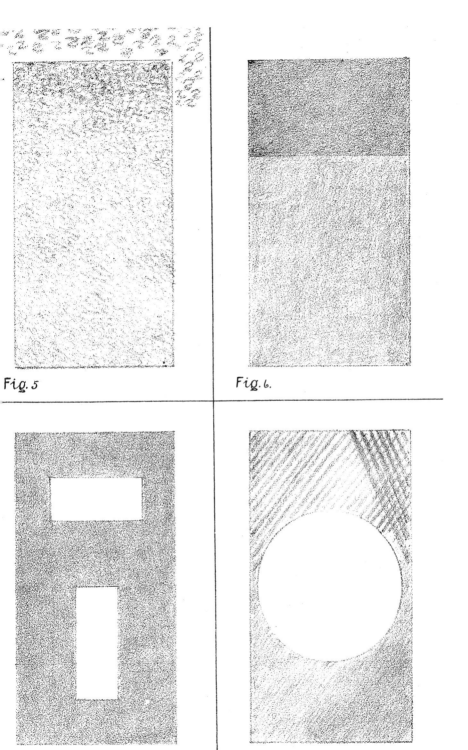

Fig. 5

Fig. 6.

Fig. 7.

Fig. 8.

corners of the rectangle; and this you will find true, no matter at what angle you may turn the card.

We learn then :—(1) *The shadow falls immediately behind the object, and along the straight line joining the object with the source of light.*

Keeping the light and the sheet of cardboard as before, place the small rectangle nearer the light. The points of the shadow can be found as before ; necessarily the shadow as a whole must be larger (Fig. 3). But you will notice that the tone of the shadow is not so deep as in the last instance, and that its edges are not nearly so distinct.

Hence :—(2) *The farther the object from the surface receiving the shadow, the larger and fainter will that shadow appear.*

If you now rest the rectangle upon the lower sheet, you will find its shadow cast as in Fig. 4. Here the part of the shadow along the floor, so to speak, gradually decreases in darkness of tone until it reaches the upright, upon which, according to the last experiments, it appears approximately of the same depth throughout.

It will be readily understood why the shadow gets wider along the horizontal plane as it recedes from the object, for the parts receiving the shadow are removed at greater and greater distances from the object. This experiment, therefore, really gives the principles underlying Figs. 1 and 3 in one.

Thus :—(3) *The shadows cast on flat surfaces by objects resting on those surfaces appear darkest along the portions nearest the object*, whence they gradually decrease in depth.

Lastly, bend the perpendicular sheet into any shape, as in Fig. 2. Place a stick of pencil so that its shadow may be caught, and notice how the shadow bends according to the surface.

Hence :—(4) *The shape of the shadow will depend largely upon the surface receiving the shadow.*

It would be well to bend the cardboard in all directions, and to use other objects for casting shadows.

Such simple experiments, varied according to your ingenuity, will be found extremely useful.

(B) *Shadows cast by Sunlight.*—The point *a* in Fig. 3 is obtained by drawing a line from the source of light L through the corner *x* of the cardboard, and *b* by drawing a similar line from L through *y*.

If now, keeping the cardboard in the same position, the light L be moved to a greater distance (say, as far as M), and lines drawn, M *x* and M *y*, and produced to strike the upright sheet, it is clear the two points *a* and *b* will not be so far apart as before. And similarly with the other points, *c* and *d*.

In other words, if you move the light to a greater distance the shadow will grow less, until, if you imagine it moved to an immense distance, from *a* to *b* will be almost equal to the line *x y*.

Now the sun is at such a vast distance from every object on the earth that its rays may be considered to pass through the points of the object, such as *a, b, c, d*, parallel to each other.

Simply, then, if you place the cardboard, as in Fig. 1, in the direct sunlight, and move the small rectangle toward and away from the upright sheet, its shadow will remain of the same size in all cases.

You may notice the same fact by observing your shadow thrown on a wall by the sun. Moving your hand to and away from the wall its shadow will not perceptibly alter in size.

(c) *Shadows cast by Diffused Daylight.*—In addition to the difficulty of obtaining direct sunlight on any group we may wish to represent, it is to be remembered that the sun is apparently moving rapidly through the heavens, so that the direction of the shadow cast by it continually changes.

If circumstances, therefore, render it compulsory that a shading shall be made by daylight, the group or cast must be placed so that it may be lighted from one window only, and that one so placed that the sun itself may not shine on the group.

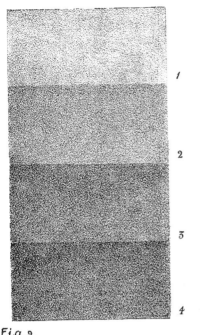

1

2

3

4

Fig. 9.

Fig. 10.

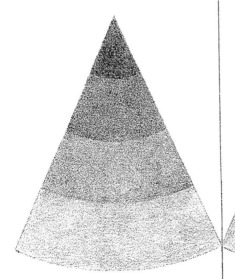

Fig. 11.

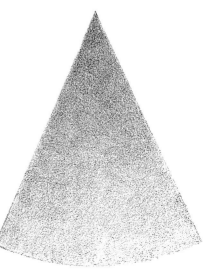

Fig. 12.

You may find by experiment that if the window admitting the light be smaller than the object, the cast-shadows will be formed along *diverging* lines, as in Figs. 2, 3, and 4; but if the window be larger, the shadows will decrease.

Since artificial light can be so much more readily arranged to suit a group, and since, moreover, the lights, shades, and shadows distributed by it are clearly defined, models and casts are generally shaded by gas-light.

Lights and Shades.

Take two small equal rectangles of white cardboard, and hold them side by side perpendicularly in the full light of the sun or of a gas-jet. Now allow the top of one to fall slowly backwards away from the light, and towards the horizontal. As it falls, compare its brightness with that of the perpendicular sheet. You will then at once gather that *the intensity of light on a surface depends upon the angle at which the light strikes that surface.* The more perpendicular the surface is to the rays of light, the lighter its tone will be.

The knowledge of this will frequently help you out of a difficulty. For instance, the left-hand leaf in Fig. 74 is almost on the same level as the background, and hence appears mainly of the same tone. Without consideration, you would find yourself apt to make this too light or too dark.

Now, if part of a surface is so placed that no direct rays can strike it (as, for example, in our first illustration, that half of the whitened ball turned from the light), evidently we must find darkness.

Such darkness is known as the *shade.*

CHAPTER II.

ON MATERIALS AND THEIR USE.

FOR the purpose of shading, in addition to the usual drawing-board, the pupil will need stumping-chalk, stumps, sticks of prepared charcoal, tinder, a Contè crayon in wood, French white paper, and, for finished drawings, Whatman's "Not."

Stumping-chalk.—This is sold either in bottles or wrapped in foil. The former is preferable, and is put up in this form by most of our large colour-makers. Every artists' colourman keeps it in stock.

A piece of rough drawing-paper, about three inches by two, should be pinned on the upper right-hand corner of the student's board, and a little stumping-chalk rubbed into it with the cork of the bottle. The lowest edge of the paper should be turned up at right angles, so that no pieces of chalk may fall on the student's work, for the board should not be placed flat.

Stumps.—These are made of leather or of French grey paper. The former are found to give the smoother tones. They are made in many sizes, but the best for our work are Nos. 2 and 3. For very large masses of shade, larger stumps may be used with advantage.

For finer work, such as bringing shades to a clear outline, and for finishing touches generally, a few *tortillons* will be found useful. These are generally sold in bundles at two or three pence a dozen.

The stump should be held between the thumb and first two fingers, so that the unused end may lie *under* the hand, and not above it, as in using the pen.

By this means the whole of the bevelled end may be utilised, and a broader and freer stroke made, than would be possible if it were held more perpendicularly. Whilst working, the stump should be slowly *rolled* by the fingers

Fig.13.

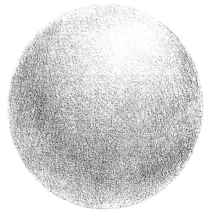

Fig.14.

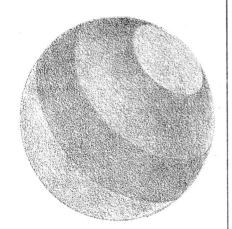

Fig.15.

Fig.16.

and thumb, so that all parts of the bevel may be brought into use.

French White Paper.—This is sometimes known as "Michallet." Parallel ridges run across its surface from right to left, so that it is much rougher than ordinary cartridge-paper. It is sold at about two pence the half-imperial sheet.

Whatman's Paper.—When the pupil wishes to make a really finished shading, he will find no paper comparable to this for his purpose. It is made in three kinds—Rough, Hot-pressed, and Not Hot-pressed. The last is generally used for chalk drawings, and is known shortly as " Not." The price is sixpence an imperial sheet.

Charcoal.—Preliminary sketches for shaded drawings are not made in black-lead, for this has a greasy nature and refuses to take the stumping-chalk. All black-lead lines—if at all strongly marked—would, therefore, appear as white threads in the midst of the black chalk.

Prepared charcoal is used instead. It is sold in sticks at two or three a penny.

All lines drawn with charcoal should be faint, as they can then be easily dusted away by tinder or a cloth.

Tinder.—This is sold by few artists' colourmen, but may be obtained direct from Messrs. Lechertier, Barbe and Co., 66, Regent Street. Dusted lightly over the charcoal, it removes the marks instantly.

But you may use a linen cloth for the same purpose, although not so effectively.

Contè Crayon in Wood.—These are sold in Nos. 1, 2, and 3, according to their degree of blackness; but for our present purpose No. 1 is to be preferred. It is chiefly useful for adding here and there intense points of black in the shadows; but may be used exclusively for adding shades to a drawing. (See Appendix.)

Bread.—Although chalk may be removed by india-rubber, a far better medium is bread, for which purpose it should not be so new as to feel sticky, nor so stale as to

crumble freely, but of such a consistency that it may be pressed into a wedge-like form.

The chalk, if it has been lightly applied to the paper, can be almost entirely removed by pressing the bread upon it.

At times a shade is found to be too dark, and to require lightening. For this purpose, bread that has been already used for removing chalk is applied to the part to be lightened. Clean bread would probably remove too much chalk.

CHAPTER III.

PRELIMINARY EXERCISES.—FLAT TINTS AND GRADATIONS.

DRAWINGS are usually shaded in one of three ways—either by means of stumping-chalk and stumps, by black-lead or crayon, or by a combination of both methods. Each has its special advantages, but there is no doubt that for breadth of effect and rapidity of execution the first is the most effective. Some masters, indeed, prefer to teach the use of the black-lead or crayon for the shading of models; but even they discard the lead for the stump when the pupil takes up the shading of casts.

As this little work is arranged systematically, we have advised the use of the stump throughout, in the belief that the practice obtained in shading large and simple surfaces, such as are met with in the geometrical solids, will be found of great service to the student when he attacks the more refined light and shade of a cast.

However, in the Appendix, the method of pencil shading by cross-hatching has been shown and illustrated by a plate. The student who prefers to use this weaker and less satisfactory method should read here that part of the Appendix, and work the exercises as recommended, and then proceed to the shading of the cube. All subsequent lessons will be applicable to either process.

Fig. 17.

Fig. 18.

Fig. 19.

Fig. 20.

I.—*Flat Tints.*

(*a*) Divide a sheet of French white paper into four equal parts. In one division sketch a rectangle (Fig. 5).

Take a stump and lightly *roll* either of the bevelled ends in the stumping-chalk placed on paper as recommended above. Then, beginning with the upper left-hand corner, and working along the top to the right, and so slowly down the paper, draw with the broad flat bevel of the stump a number of s strokes, as shown along the upper margin (Fig. 5). Small spaces will evidently be left between these s strokes.

As you approach the bottom, place the strokes closer together, so that the spaces between become smaller and smaller. As you work, slowly turn the stump, and when the chalk becomes exhausted, replenish as before. You should not place the s strokes in regular lines, but scattered.

Probably, when complete, the tint will show black spots here and there; if so, lighten them with bread. With practice, you will be able to get an even tint at once.

These first exercises are very important, and you must beware, above all, of hasty and slovenly work. Rapidity must come with practice, but uncertain and excited work can only lead to bad habits of work that you will find difficult to eradicate.

(*b*) Fig. 6 shows the second rectangle tinted in the same fashion. Here, however, the strokes are smaller and closer together; while the upper portion shows the same, but obtained by keeping the stump more heavily charged with chalk. In this way—by loading the stump with, or partly freeing it from, chalk—flat—*i.e.*, even—tints may be made of many different depths.

When shading, remember to work carefully and *lightly*. Do not *scrub* the chalk into the paper, for this is made purposely rough that the projections only may be caught by the stump, leaving the hollows shining between.

(*c*) Fig. 7.—Rule some such rectangles as shown, and

surround them with an even tint, which should be brought accurately to the very edge, without encroaching on the space within. This is a very useful exercise, for you will find subsequently how important it is to keep with clean edges all tones that meet an outline.

(*d*) Fig. 8.—You will probably at first find it difficult to get a large mass perfectly even. Some accomplish this better by shading with the stump in straight lines, as shown in this figure. Of course they must be placed close together, so as to form a tint rather than an assemblage of straight strokes. You will see what is meant by comparing the lower part of the figure with the upper.

By this method, however, the work is apt to look " stringy "—a fault which may be partly remedied by carrying other strokes across in contrary directions, as in the upper right-hand corner of the figure.

You are not recommended to use this stroke except for flat tints ; and not then, unless by its means you are able to get a smoother effect.

II.—*Gradations.*

(*a*) Divide another sheet as before, and after drawing in one division a rectangle, divide it equally by lines drawn at right angles to its length (Fig. 9). Fill these divisions with flat even tints, gradually increasing in depth from one to four.

(*Note.*—The tints do not appear to be flat, but fluted. This is merely the effect of contrast.) [*See* Chapter V.]

(*b*) Fig. 10.—Mark here a rectangle equal to that in Fig. 9, and beginning with a light tone, gradually add more and more chalk until you reach a depth equal to that of four in Fig. 9.

(*c*) Fig. 11.—A sector of a circle divided into parts by concentric arcs is shown.

As before, fill in each division with *even* tints, beginning, however, with the darkest.

(*d*) Fig. 12.—The same sector is shown without the

dividing arcs. Charge the stump well with chalk, and as you approach the circumference, from time to time, if necessary, remove some of the chalk by applying it to a rough paper placed near at hand.

III.—*Gradations (continued).*

Divide another sheet, and in the first quarter draw the divided rectangle (Fig. 13).

(*a*) Fig. 13.—Begin with the central rectangle, and fill it evenly with a dark tone. Work then to the first on the left and then to the first on the right; next, with a still lighter tint, to the second on the left, and to the second on the right.

(*b*) Fig. 14.—Mark very lightly with a stump a line down the centre, to act as a guide for the direction of the darkest tone. Starting from the top of this line, work down it to the bottom, and then gradate first to the left, then to the right, and then again to left and right, as shown above (Fig. 13). (*c*) and (*d*), Figs. 15 and 16, are merely repetitions within curved lines of (*a*) and (*b*). Begin as before with the darkest tone, and work from it in either direction.

IV.—*Gradations over a Tone.*

It is advisable in your earliest efforts at shading gradated tones to cover a surface first with an even tone equal in depth to the *lightest portion* of the shade, and then to cover this with what slight gradations may be required.

As you become more expert, you will be able to lay a shade with its gradations at once and with decision, but this power can only come with time. In the meantime, you will find it best to work as recommended here.

Let us suppose a shadow gradates from one corner of a rectangular surface to another.

(*a*) Fig. 17.—First cover the rectangle with an even tint, equal in depth to the *lightest portion* of the tone to be

represented. (The small dark patch shows the commence-ment of the gradation.)

(*b*) Fig. 18.—Over this, beginning at the darkest point, gradate until the tone dies away into the flat tint first laid.

(*c*) and (*d*), Figs. 19 and 20, are merely modifications of (*a*) and (*b*). In gradating (*d*), be careful that the tone dies away in imaginary *curves*, whose centre lies at the highest and brightest point.

We now proceed to the solids, which the pupil is advised to draw to a large scale—say nine or ten inches in length.

It should be understood that the plates given are not to serve as shaded copies, but in all cases the models them-selves should be arranged as nearly as possible under the conditions shown by the figures; for these are, indeed, merely to serve as guides to the student's own observation.

CHAPTER IV.

THE CUBE, HEXAGONAL PRISM, AND CYLINDER.

The Cube.

WE shall show fully each step to be taken in shading this model, for this solid is a representative of all prisms, and, indirectly, of the cylinder.

Place the cube on a sheet of light brown paper, and pin against the wall behind it a similar sheet to serve for back-ground. Let the light fall from the right and from above the cube. The top face will be the brightest of those seen, and the darkest will necessarily be that next the cast-shadow.

Step I. (Fig. 21).—Draw the cube *carefully and lightly* in charcoal. Incorrect lines may be removed by dusting with the tinder. Do not draw with black-lead, as it is greasy, and will afterwards appear white in your shading.

Now draw carefully the cast-shadow, noticing at the

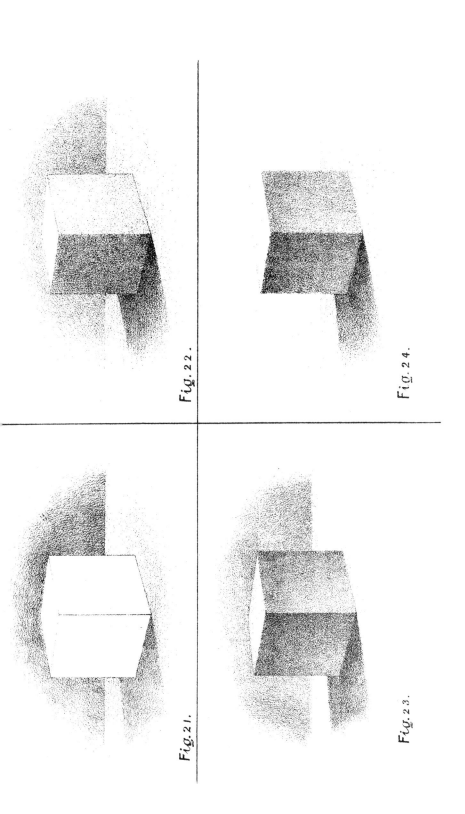

Fig. 21.

Fig. 22.

Fig. 23.

Fig. 24.

same time how much darker it appears than the background, and that (Fig. 4) it gradually decreases in depth of tone as it recedes from the cube. Shade this shadow as light as its *lightest part*. Put in the background and ground-plane rather lighter than they appear.

Step II. (Fig. 22).—The two perpendicular faces seen differ in depth of tone. Decide the tone of the darker in relation to the cast-shadow and the background, and of the lighter in relation to all three. Shade each of an *even tint*, equal in depth to the *lightest part* of each.

Step III. (Fig. 23).—Partly owing to reflected light from the ground-plane and partly to the effect of contrast,* a light gradation appears on each perpendicular face, working from the upper right-hand corner and along the right edge towards the left. Lay on each carefully (*see* Fig. 18), being careful not to get them too dark. (The *lowest part* of the side next the cast-shadow receives little reflected light, and should be slightly shaded.)

Step IV.—The cast-shadow is darkest nearest the cube, and its outline is most clear in the same part (Fig. 4). Add this gradation to the shadow.

The upper face, although light, is not white. A slight tone will be noticed gradating from the back edges to the front, where the effect of contrast with the darker perpendicular faces will help to make it lighter still. Lay this gradation very lightly. It may be necessary to free the stump almost entirely of chalk.

The background may now be darkened along the edge of the top face (again the effect of contrast), and the drawing is complete.

Fig. 24 shows the same cube without a background. In this case it may be necessary to faintly mark with a crayon the further edges of the top face.

* The law of contrast runs thus :—If two tones of different depth stand side by side, the lighter of the two will appear still more light along the edge next to the darker tone, and the darker tone still more dark along the edge nearest the lighter tone. (*See* "Contrast," Chap. V.)

The brightest part is near the front edge.

You will notice that the brightest light and the deepest dark are small in quantity ; this is so on every object.

" White should be regarded as the jewels of your picture, and used with great discretion. One diamond will attract—a cartload makes them common." (Hume Nisbet, " Life and Nature Studies.")

Recapitulation. (Method for all models.)

1. Draw carefully the model and its shadows.

2. Shade—of their lightest depth—the cast-shadow, background, and ground-plane.

3. Lay the *shades* on the model evenly, beginning with the darkest and proceeding to the next lighter—in all cases making them throughout equal in depth to their lightest part.

4. *Grodate* the tones on the model.

5. Darken the cast-shadow where required.

6. Add *slight* tones to the background near the edges of the model, to show the effect of contrast.

Leaving the cube as it stands, you would find it useful practice to alter your position, and make drawings from all points of view.

The Hexagonal Prism.

The shading of pentagonal, hexagonal, and other prisms presents no difficulty to one able to show the light and shade of a cube.

In this case, the hexagonal prism stands under the same conditions as the cube in the last lesson. As we saw there, the faces receiving the most direct rays will be the brightest, the other increasing in depth of tone as they turn from the light. (*See* on " Shades " in the last chapter.)

Step I. (Fig. 25).—Sketch prism and shadow. Shade the shadow, background, and ground-plane.

Step II.—Put on, with an even tint throughout, the tones of the two dark perpendicular faces, judging carefully their

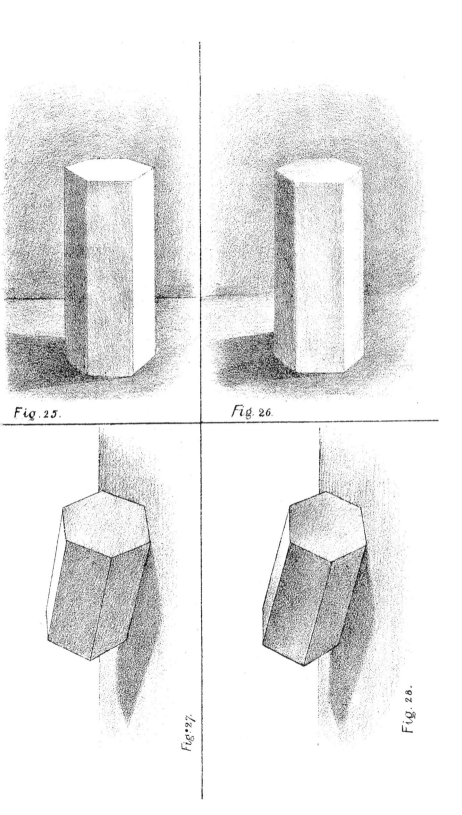

Fig. 25.

Fig. 26.

Fig. 27.

Fig. 28.

general depth of shade in relation to the cast-shadow and the background.

Step III.—As with the cube, gradations work from the upper right-hand corner of each face, and for the same reason (*see* Cube, Step III.). Thus contrast will cause the whole right edge of each face to appear slightly darker.

The lightest perpendicular face (that nearest the light) shows similar gradations to the others, but in a lighter key. Compare its general tone with that of the upper hexagonal end—which has likewise a gradation from back to front.

Step IV.—Darken the cast-shadow, clearly defining part of its nearest edge. The darkening of the background round the upper hexagonal end and along the lightest perpendicular face will help to relieve them from the background.

It is to be noted that the darkest portion of the perpendicular faces is not on the extreme left edge, neither is the lightest portion on the extreme right.

The Hexagonal Prism lying on one of its Rectangular Faces.—Place the prism as in Fig. 27. The light shines from above. Necessarily, the faces turning away from the direct light increase in depth of tone. In this case, however, the reflection from the ground-plane is very clearly marked on the lowest face, because that side is turned at an angle to receive it. So strong may this reflection be that the whole lowest face may be lighter in tone than the one above.

The effects of aërial perspective will be seen in altering slightly the tones on the further end of the prism.*

In this drawing we have shown an outline throughout. This is a useful method for rapid shading, but is to be discarded in all finished work, where outlines should be shown as in Nature—by the meeting of two tones of unequal depth.

Step I.—Shade evenly the cast-shadow, background, and ground-plane ; the lowest shaded face, though brightened

* The law runs thus:—Distance alters the relationship between lights, shades, and shadows ; the lights grow darker, the shades and shadows grow lighter. (*See* "Aërial Perspective," Chap. V.)

by reflection, is still in shadow, and *must therefore be shown much darker than the top face;* for reflected light in shades never appears so bright as the half tone.

Lay on the shades of the two lower faces.

Step II. (Fig. 28).—A gradation on the middle shaded rectangular face works from right to left. Contrast with the bright upper face and with the hexagonal end causes the edges to be slightly dark. As the face recedes, the effect of aërial perspective will be seen in making the whole of a more even tone.

The face beneath should be darkened a trifle along its lowest edge, where it catches little reflection.

Step III.—A gradation on the hexagonal end from right to left should now be added. Contrast with the darker shaded faces causes the left edge to appear light.

The top rectangular face should be gradated from the further edges to the front, where the effects of contrast are seen. The end of this face removed from the spectator receives a slight tone to show the effects of aërial perspective.

Step IV.—Gradate the cast-shadow.

The Cylinder.

The cylinder may be regarded as a prism with an infinite number of sides. We will suppose it to possess for our present purpose about twenty faces, of which half are seen from the front (Fig. 29). Now, by referring to the hexagonal prism it will be evident that if the light fall as indicated by the arrow, the faces 1, 2, 3, 4, 5, 6, 7, 8 should become darker and darker as they turn from the light.

As we saw both in the cube and the hexagonal prism, the deepest shade is not on the extreme edge, because of reflection from the ground-plane, so in the cylinder we shall find the same fact repeated.

But in the hexagonal prism the shades are sharply defined because of the bounding edges of their rectangular faces, while in the cylinder these (imaginary) faces blend

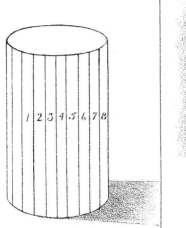

Fig. 29.

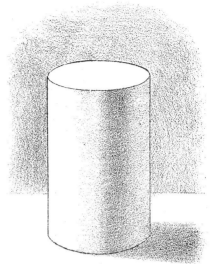

Fig. 30.

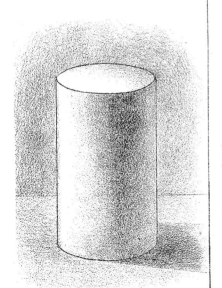

Fig. 31.

Fig. 32.

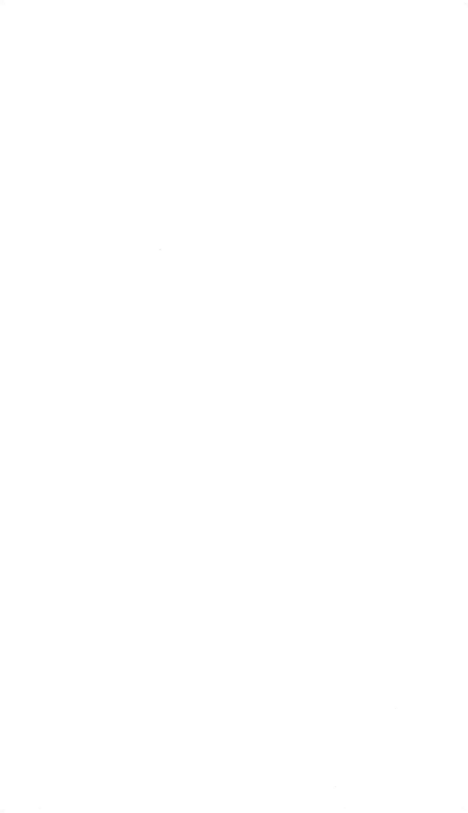

together, so that from the extreme dark there will be an even *gradation* towards the light.

Step I. (Fig. 29).—(You are not to draw the faces, which are merely drawn for the purpose of illustration.)

Shade the cast-shadow and background evenly.

Lay the shade of a depth equal to its lightest portion, and then over this lay a gradation towards the right edge. (*See* Fig. 18.) A light line drawn down the solid will help to guide you in shading this.

Step II. (Fig. 30).—Add a slight gradation towards the high light. (Notice that the high light runs in a line down the figure, for it really represents the imaginary face of the prism turned directly to the source of light.)

The high light will not lie quite at the edge, where there is a faint tone gradated from the high light to the edge. We have seen similar instances in the cube and hexagonal prism.

Step III. (Fig. 31).—The circular end shows a gradation towards the front as in the hexagonal prism, and, just as in that solid, the edges of the tones on the sides appear slightly darker where they meet the lighter edges of the top face.

Step IV.—An addition of tone to the cast-shadow and to the background along the lighter portions of the figure completes the drawing.

Cylinder lying down.—This should be compared with the hexagonal prism in the same position (Fig. 28).

If the cylinder, lined as in Fig. 29, were to be placed on its side with the face marked 1 uppermost, and if, moreover, the light strike the face from above, it is clear that the other faces, 2, 3, 4, &c., should show increasing depth of shade. But (exactly as with the hexagonal prism in a similar position) a good deal of reflection from the ground-plane lights up the lower (imaginary) faces, so that the darkest portion will run some distance from the edge. The method of shading will be as before.

Step I.—Shade the cast-shadow, background, and ground-plane. Lay on the shade and add its gradations.

Step II.—Mark the line of high light, and add a faint gradation from the edge of the shade towards it.

Step III.—The perpendicular circular end shows another gradation towards the shaded surface of the cylinder, as we have seen in the cube and hexagonal prism.

Be careful to keep this much lighter than that part of the shade lit up by reflection. The broad division into the two masses of light and shade must be maintained in all cases. It will be noticed that the effects of aërial perspective are shown on the end removed from the spectator.

In this chapter the student is supposed to be sitting almost at right angles to the direction of the rays of light shining on the solids. It would be a useful practice to leave the objects as they stand, and draw from other points of view.

For instance, he might move his position a trifle to the left of the upright cylinder, when the darkest shade will be seen on the very edge, while the reflected light has disappeared behind the solid. Yet he should know exactly how the lights and shades are distributed over the surfaces of the various models, although he may not see them all from the position he may be occupying.

The student must be warned against expecting to find bright high lights and strong reflected lights on every cylinder, or, for the matter of that, on every solid. These will be decided primarily by the polish of the surface and by the proximity of light objects. For example, you would not expect to find high and reflected lights as strongly marked on the trunk of a tree as you would on an enamelled earthenware jug.

Fig. 33.

Fig. 34.

Fig. 35.

Fig. 36.

CHAPTER V.

ON CONTRAST OF TONES ; AND ON AËRIAL PERSPECTIVE.

Contrast.

WE have had occasion to mention the law of contrast in our former chapters, but we thought it better to leave till now a fuller explanation of its effects.

In Nature we meet with an infinite variety of lights and shades, at times strongly opposed, at others blending together almost imperceptibly. On a light summer evening the trees stand out dark and clear against the sky, and we recognise at once that the trees look darker than they would if seen with a heavy building for background—for they stand contrasted with the light sky. But careful observation would show that the sky itself immed ately surrounding the dark trees appears brighter than parts more remote.

As a further illustration, we may mention a fact familiar to all—that colours appear most intense when placed in juxtaposition with their complementaries. A scarlet geranium seems more brilliant on the stalk and surrounded by its green leaves than when plucked and placed among other blooms. And so the purple heather and yellow cowslip, the orange marigold and blue flag, placed respectively side by side, intensify the colours of each other.

And therefore black—the absence of all colours—is deepened by the juxtaposition of white—the sum of all colours ; and the white heightened at the same time by the neighbourhood of the black. A few experiments should make this evident. If you place a small piece of black velvet on a sheet of white paper, and look at both attentively for a few seconds, you will see that the paper in the neighbourhood of the velvet appears whiter than before.

It is not so easy to show that the black itself is deepened in tone at the same time, although by careful observation you may see it is so.

Having drawn with black-lead upon white paper a small square of about one inch side, shade it by carrying the pencil lightly backwards and forwards in all directions until it assumes an even grey tint. Looking closely, it will be found that the edges appear darker than the centre.

Again, Figs. 9 and 11 have both a fluted look, and yet each tint is of the same depth throughout. The lowest but one rectangle in Fig. 9, for instance, appears darker along its upper edge than along its lower; yet, if you cover all the sheet but this same rectangle, you will find it is of an even shade.

Its lower edge, in fact, is lighter by contrast with the dark tone beneath; its upper, darker by contrast with the lighter rectangle above.

We therefore arrive at this law :—*If two tones of different depth be placed side by side, the lighter will appear still more light along the edge next the darker tone; the darker still more dark along the edge near the lighter tone.*

The application of this law has been already seen in our past lessons, and will occur again and again.

Aërial Perspective.

A church seen first from near at hand, and then from a distance, changes in appearance in several distinct ways. It appears much smaller, and its vanishing lines are less acute—effects that are explained by the laws of "linear" perspective.

But, in addition to these, distance causes changes no less marked in colour, light, and shade. Thus, standing close to the church, you see its lights and shades distinct and clearly defined, but from a distance they appear much more uniform in tone. The lights become less brilliant, and the shadows less intense, until from afar they all assume an even grey.

Such changes are due to the vapour suspended in the air. Evidently the greater the distance, the thicker the stratum of vapour through which we look. Moreover, when

Fig.37.

Fig.38.

Fig.39.

Fig.40.

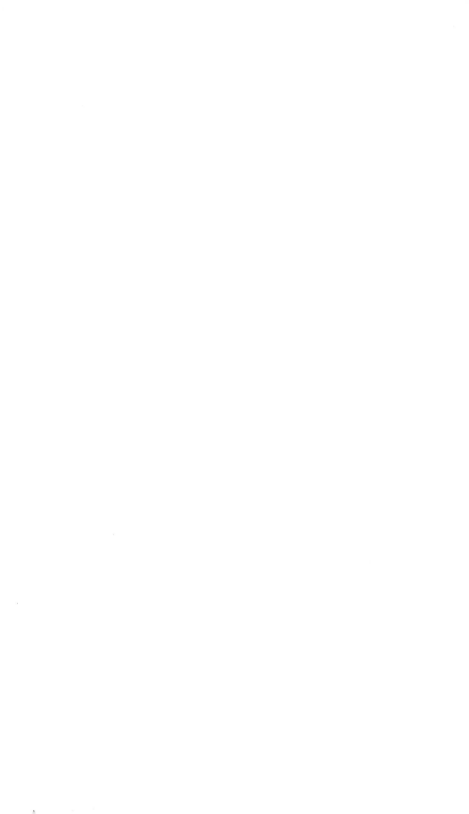

this vapour is present in greater quantity, the effects are more marked—to what degree may be seen on any misty day.

In bright, dry Eastern climates, distant objects seem to glare to a European accustomed to an atmosphere more humid.

The better-class magazines, as the " Art Magazine," "Harper's," and the "English Illustrated," frequently contain engravings in which you may see how carefully the artist has distinguished between the lights and shades of objects in the foreground and those in the distance.

These air effects, however, make themselves apparent to an educated eye within a distance of a few feet. If, for example, Fig. 56 represents a group of models seen from a distance of ten feet, the same group would show far less variety of light and shade seen from a distance of twenty. Even in the group as it stands, the lights and shades on the vase are more distinct than those on the further ends of prism and cylinder.

Similarly, the ends of models receding from the spectator have their shades less sharply defined than those on the nearer ends (Figs. 28 and 32).

For our present purpose it will be sufficient to simply state the law of aërial perspective, leaving the student to test its truth :—

The relationship between lights, shades, and shadows is altered by distance : the lights grow darker and the shades and shadows lighter.

CHAPTER VI.

ON PYRAMIDS, THE CONE, AND THE SPHERE.

THE shading of pyramids and cones will present little difficulty if the principles of light and shade that determine the position, depth, and gradation of tones upon the surfaces of prisms and cylinders have been thoroughly grasped.

In pyramids, we find no longer perpendicular but sloping faces; and in this consists the only important difference between the two classes of figures.

The Square Pyramid.

Place a square pyramid, as in Fig. 33, with the light falling from above and from the right. The sides turned to the light will, of course, be brighter than the others.

As the shaded sides slope *from* the ground-plane, the reflected light will have less effect upon their upper portions than it would upon the corresponding parts of perpendicular faces. Hence, when pyramids stand with their axes upright, the portions in shade near the apex will show little gradation.

Step I. (Fig. 33).—Shade evenly the cast-shadow, background, and ground-plane.

Step II. (Fig. 33).—Shade the dark face of the pyramid of a depth equal to its lightest portion, comparing this tone carefully with the cast-shadow and the background.

Step III. (Fig. 34).—As in the cube, a gradation is seen from the right edge of the shade. The portion near the apex will appear especially dark, as there is little reflection to lighten the tone.

Step IV.—The lighter side shows a similar gradation, so that the brightest portion of the figure will be along the edge nearest the spectator; for this brightness is heightened by contrast with the darker side. Lay on this gradation lightly. It should be noticed how bright the apex appears by contrast.

Fig. 41.

Fig. 42.

Fig. 43.

Fig. 44.

Darken the shadow next the pyramid and along its front edge, and the background near the light face.

The lowest edge of the darker side receives little reflected light, and should be slightly shaded.

The Hexagonal Pyramid.

Place an hexagonal pyramid that the light may fall from the right, and that three faces may be seen from the front. In this case, for the sake of variety of practice, the solid is shown without a background. It may be necessary to outline lightly some of the extreme edges, especially that of the lightest side.

The shading of the lightest and darkest faces will be exactly similar to that of the square pyramid. The middle face is intermediate in tone, but its gradations fall from right to left, as on the other two faces.

Step I. (Fig. 35).—Shade the cast-shadow, ground-plane, and the two faces in shade all of an even tint, equal to their lightest portion.

Step II. (Fig. 36).—Add gradations to the shaded faces, keeping the darker edges clear.

Step III.—Gradate the cast-shadow and the lowest edge of the darkest side. The corresponding part of the intermediate face receives reflection, and should not be darkened.

The ground-plane abutting on the lightest face may also be slightly shaded.

The Cone

As the cylinder may be looked upon as a prism with an infinite number of faces, so the cone may be considered a pyramid whose base is a polygon with an infinite number of sides.

If Fig. 37 represent such a pyramid, and the light fall from the right, as indicated in the diagram, clearly the sides 1, 2, 3, &c., should grow successively darker in tone. But we have seen, both in the square and hexagonal pyramids,

that the darkest portion is not along the outer edge of the darkest side, because of reflection from the ground-plane ; similarly the deepest shade on the cone will be removed from the edge.

Again, the high light on the pyramids runs along a line ; and so it will be found on the cone.

Moreover, the shade nearest the apex will be least affected by reflection.

Step I. (Fig. 38).—Shade the cast-shadow and the background. Draw lightly on the cone the edge of the shade, and lay on its tone of a depth equal to its lightest portion. The right edge should not be brought to a *sharp* outline, but allowed to be rather uneven, so that the gradation to the high light may be more truthfully rendered.

Step II. (Fig. 39).—The darkest shade runs from the apex down the shade and near to its outer edge, whence it gradates to the left.

The high light may be taken to represent the light falling on one of the sides of our imaginary pyramid ; in this case, the side 1.

Mark the high light with charcoal, so that it may afterwards be easily cleared.

Fig. 40.—The portion in half-tone gradates to the high light. Be careful to keep the whole tone light—much brighter, in fact, than the reflected light.

Step III.—Darken the cast-shadow and the shade along its lowest edge. A light gradation on the background near the light edge will complete the drawing.

The cone lying on its side can be easily represented by reference to the cylinder in a similar position, and to the cone with its axis perpendicular.

The Sphere.

A solid india-rubber ball whitened with chalk will do very well if this model should not be supplied with the set. In such case the ball must of course be placed nearer the student.

Fig. 45.

Fig. 46.

Fig. 47.

Fig. 48.

Fig. 49.

Place the sphere so that the light falls from the left and from above.

If now this light fall in the direction indicated by the arrow (Fig. 41), the point immediately under the light—where the rays strike most perpendicularly—must necessarily be the brightest. As the surface of the sphere falls gradually away on all sides from this point, the light strikes at a less and less angle, and we should therefore expect to find a gradation on all sides from the high light.

The rays at length fall so acutely that they form tangents on all sides of the sphere. The line joining these touching points will be a circle, and will mark where the half-tone ends and the shade commences.

Thus, if we consider the perpendicular ray to pass through the sphere as an axis, circles drawn on the surface of the globe in planes at right angles to this line will have all the points in their respective circumferences at equal distances from the pole : *i.e.*, from the high light.

Thus the depth of tone should be equal all along the circle *b c*, and so with *d e* and *f g ;* and, as we have seen, the edge of the *shade* will run along a circle at right angles to the line of direct light (Fig. 42).

Step I. (Fig. 42).—Indicate lightly the position of the high light and the edge of the shade on the sphere. Draw carefully the cast-shadow. Shade the shadow, background, and ground-plane. Put on the tone of the shaded portion equal in depth to its lightest part.

Step II. (Fig. 43).—As with the cylinder lying on its side (Fig. 32), the darkest shade is not found next the ground-plane, for the lower parts will be brightened by reflected light. The darkest part will therefore appear near the edge of the shade, and will thence gradate towards the ground-plane.

Add this dark tone and gradate.

Step III. (Fig. 43).—Gradate the half-tone lightly from all sides towards the high light.

Step IV.—Darken the shadow under the sphere, and

add a slight tone on the shade, just beside the shadow, where it receives little reflection.

The Egg.

The instruction given for shading the cylinders and the sphere renders it unnecessary to speak at large upon this solid.

An egg placed near at hand on a dark ground will suit admirably (Fig. 44).

You have but to notice that the high light and the deepest shade will bend according to the curvature of the egg.

If you refer to the shading of the egg plant (Fig. 76), you will find instances of this.

CHAPTER VII.

ON VASES, WHITE AND COLOURED.

THE cube, hexagonal prism, cylinder, square and hexagonal prisms, cone, sphere, and egg will be found to enter largely into the shapes of any common objects you may be called upon to draw and shade.

Objects of rounded surface will be found to approximate in shape to either the cylinder, cone, sphere, or egg, or to a combination of these shapes. Therefore, we shall look to find these in all kinds of vases.

Those selected for illustration may not be accessible to the student. In that case he should make enlarged copies of the engravings, and shade according to the directions given. He may then with confidence attack the shading of other vases. But if he can meet with vases approaching the following in shape, he should draw and shade direct from the objects themselves.

The Long-necked Vase may be looked upon as consisting

of three parts—neck, bulb, and foot; the first of which (Fig. 45), *b*, is a cylinder; the second, *c*, a sphere; and the last, *d*, part of a cone.

The light falls from above and from the right.

Step I. (Fig. 45).—Draw the vase very carefully, and then mark the cast-shadow of the bulb cast on the foot and along the ground-plane. Sketch very lightly with charcoal the outline of the shade on the neck and bulb, and shade it and the cast-shadow of a depth equal to their lightest tone.

Step II. (Fig. 46).—The neck is cylindrical; its darkest portion will therefore lie away from the edge. Its high light will run in a line down the neck.

The bulb is a sphere, and the edge of its shade will run at right angles to the direction of the rays of light. Its high light will be centred in a spot.

Mark these high lights and add the darkest portion to the shades. These will be near the right edge, whence they will gradate to the left.

Reflection will lighten the lower right-hand portion of the bulb, while that on the left will be dark, turned away as it is from the reflected light.

Step III. (Fig. 46).—The portion marked *a* will be found to be dark and to have a clear-cut edge; for this is the *shadow* cast by the neck along the bulb.

For the same reason the shadow of the bulb on the foot will show a clean edge. (*See* Fig. 48, where the foot is enlarged.)

Step IV. (Fig. 48).—The foot is part of a cone, and if there were no cast-shadow overlying it, the darkest portion would appear removed some little distance from the left edge, whence there would be a gradual gradation to the high light on the right. Now, although the greater portion is overlaid with shadow, these differences are maintained, though in a darker key. The foot as a whole appears darker than either bulb or neck.

The high light runs in a line. (*See* Cone.)

Step V.—Gradate the half-tones on neck and bulb towards the high light.

Fig. 47.—The lip and inside of the neck are shown enlarged. Within, as we might expect, the point *b*, immediately opposite the light, will be brightest. The shadow thrown by the rim should be clearly drawn. Its darkest portion will be found nearest the edge of this shadow at *a*, for the other part is lit up by reflected light.

(This gives the shading of the inside of hollow hemispheres, such as bowls.)

In showing such minute detail it will be found advisable to use smaller stumps. The darkest portions may be inserted with the crayon.

The Long-bulbed Vase consists of three portions—neck, shoulder, and bulb; the first a curved cylinder, the second a hemisphere (as far as B C), and the last a cylinder.

The light falls from the left.

Step I. (Fig. 49).—The rim casts a shadow on the neck. Its outline gradually becomes less defined as the shade sweeps down the vase.

Draw this and the cast-shadow along the ground, and indicate lightly the edge of the shade on the vase. The high lights will be a spot on the shoulder and a curved line along the bulb. Mark the position of both.

Shade the cast-shadows, noticing that the darkest of all is under the lip. Then lay the shades on the vase all of their lightest depth.

Step II. (Fig. 50).—Darken the shades near the left edge, and gradate towards the right. Notice how these follow the forms of the sphere and the cylinder.

Step III.—Gradate the shades towards the high lights.

The neck, being cylindrical, will appear darkest away from the light, but not quite on the edge; and overlaid as it is with a shadow, these differences will still obtain, as we saw with the foot of the last vase (Fig. 48). The whole tone will simply be darker throughout.

Add the necessary gradations in this shadow, and darken

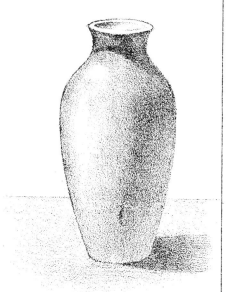

Fig.50.

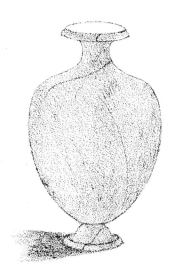

Fig.51.

Fig. 52.

Fig.53.

Fig.54.

especially the right hand of the shadow. The inside of the lip will require care.

Step IV.—Deepen the cast-shadow along the ground-plane where necessary.

Coloured Vases.

Hitherto, we have been dealing with white surfaces, which show minute differences of light and shade that are partly lost on dull coloured objects. Yet, if we were to colour any of the geometrical models, we should still find its masses of shades and lights distributed as before, though the gradations would be less marked, and the effects of reflection not so pronounced. Now, common objects are seldom white, so it is well to see how the presence of colour modifies their tones.

The vase selected for illustration was coloured a dull red. If you take two rectangles—one white, the other red—and place them on a sheet of light brown paper, it must be evident that to express the *tone* of both, without using colour, you must shade the whole of the red darker than the white rectangle. There would, therefore, be three tones : the darkest to represent the red rectangle, the next in tone for the ground-plane, and the lightest for the white rectangle.

Among several coloured objects you will at first find it difficult to decide which is lightest and which darkest in *tone.* You should first select those whose colours are strongly marked, until you are able to appreciate finer differences.

But to the vase in hand. As it is coloured, its whole tone must be dark.

Its cast-shadow, however, will be scarcely darker than that thrown by a white vase. In the latter, a slight reflection from the body of the vase may partly lighten the cast-shadow, but very slightly. Broadly speaking, cast-shadows do not depend for their intensity upon the colour of the objects that cast them.

Hence, since the whole shading of this red vase will be in a dark key throughout, there will be less difference between the depths of its shades and its shadows along the ground.

Step I. (Fig. 51).—Cover the whole vase with a tone equal in depth to the apparent lightest part of its surface.

Draw the cast-shadows on the ground and on the vase. There are three: that from the rim along the neck, a second from the bulb along the foot, and the third of the whole vase along the ground.

Step II. (Figs. 51 and 52).—Mark the outline of the shade. Shade the cast-shadows, of which the darkest will be that thrown by the rim.

Step III. (Fig. 52).—The neck is cylindrical, the bulb egg-shaped, the foot a cone. There is no need to recapitulate the principles of light and shade that apply to these bodies.

Mark the high light on the bulb, and lay in the shade of an even tint.

Step IV.—Gradate the half-tones on the bulb, rim, and foot, towards the high lights, which, of course, will not be *white.* (You must remember, however, that if the vase were *glazed* its high lights would then be quite white.)

Darken the cast-shadow where required—under the rim to the right, under the bulb to the right, and on the ground near the vase.

Fig. 53 gives an enlarged drawing of the neck, and Fig. 54 of the foot. Careful consideration of the vase with these in hand should make the method of shading clear.

Vases are difficult objects, and should be placed in all possible positions. If you mentally analyse them into the geometrical forms to which they approximate, you should be able to account for all lights and shades upon them.

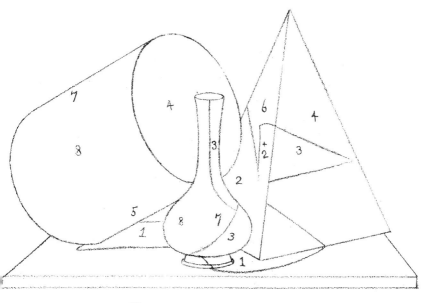

Fig. 55.

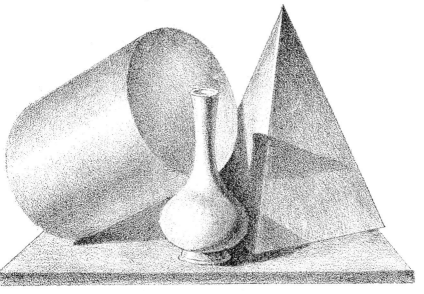

Fig. 56.

CHAPTER VIII.

ON GROUPS; TIME-TESTS; COMMON OBJECTS.

WHEN models stand in groups, we find their *masses* of tone falling mainly as when the objects are alone; but the proximity of others will modify their lights and shades by reflection or by cast-shadows. Thus, in Fig. 56 the under side of the cylinder is lit up considerably near the vase by reflection from its bulb; and a shadow from the neck of the vase sweeps strangely across a face of the square pyramid.

Step I. (Fig. 55).—Arrange a group as shown, with the light from the left. Draw the whole carefully, and sketch in all shades and cast-shadows. (If you intend making a finished drawing, it would be well to transfer the whole to a sheet of Whatman's " Not."—*See* Appendix.)

Step II. (Fig. 55).—Either in a corner of your paper, or on a separate sheet, make a sketch of the group in pencil about as large as here shown. Look carefully through the group, decide on the darkest tone, and mark this on your sketch with a figure 1; find the next darkest, and indicate this by 2; and so on. You may find several parts of the same depth (as 3 in sketch). In each case, mark with the same figure.

By using this method you will be quite decided in your mind from the beginning: a great advantage when you are working against time. It will also prevent your following the absurd practice of shading one object completely before touching the other members of the group—a practice by which all *breadth* of effect is lost.

Step III. (Fig. 56).—Shade evenly all portions marked 1; proceed to those marked 2; and so on.

Step IV.—Add all gradations where required.

Probably, for a first group the cylinder and pyramid would be found sufficient. Whether simple or complicated, the method is the same.

Be sure your outline is correct, for mistakes in this will only be emphasised by the shading. Work slowly. Samuel Prout says : "Correct drawing is essential to every work of art ; nothing can atone for the want of it, and without it all other excellencies will be valueless. It is one thing to draw, and another to draw correctly. Rapidity may be, and is, desirable, but only when it results from the confidence of knowledge, and is united with correctness."

Time-Test in Model Shading.

In this examination by the Department the time allowed the candidate for the second grade depends upon the difficulty of the group, and is decided by the inspector.

In the third grade examination, two and a half hours are given; and since the group drawn (Fig. 56) is of average difficulty, and has to fill a half-imperial sheet, the candidate will find it important to work systematically ; for experience will prove that method is infinitely preferable to an uncertain way of setting to work.

You should endeavour to give a good general broad effect of the group. Let it above all be drawn *correct in outline.* Next sketch carefully the shadows and shades throughout, and then block them in of their average depth.

The numbered sketch would be found of material assistance, for, by working over the whole group in this way, one is more certain to obtain *breadth.*

An hour given to outlining, and another to the blocking of shades, will leave half an hour, in which the candidate should endeavour to make a more finished shading of the principal object in the group—in this case, the vase.

Common Objects.

If these are treated as though composed approximately of the common geometrical forms, there should be little difficulty in deciding the position of their shades. (*See* on Vases.)

Thus, on the *cube* are based such objects as boxes,

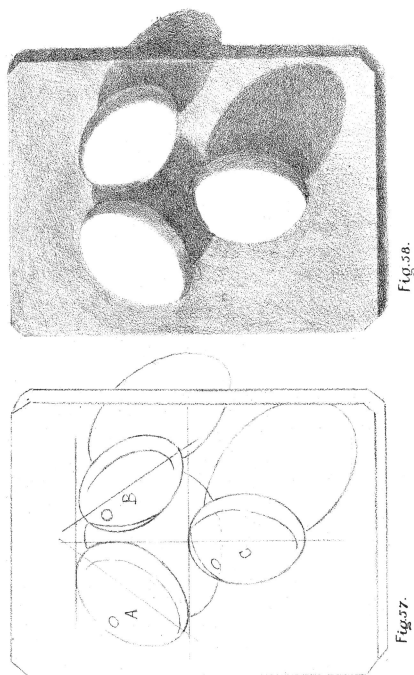

Fig.58.

Fig.57.

books, some articles of furniture, buildings, square towers ; on the *hexagonal* and other prisms, columns and turrets ; on the *cylinder*, trunks and boughs of trees, jugs, flagons, cups, some kinds of coffee and tea-pots ; on the *sphere*, bowls and many kinds of fruits, as the apple; on the *pyramid* and *cone*, roofs, spires, fruits, and roots.

In shading such, especially if they have dull surfaces, the gradations and reflections will not be very evident, and you must only represent the shades as you see them. Broadly speaking, these shades will appear as on the white geometrical models, robbed of their finer gradations.

CHAPTER IX.

ON SHADING FROM THE CAST.

THIS subject may be taken up either before or after the previous lessons. It would, however, be decidedly better to pass through such a course, as the differences of light and shade and the effects of reflection and contrast are more readily seen upon large surfaces (such as are met with in the geometrical solids) than upon the cast.

Should the student decide to begin with cast-drawing, he should first read Chapters I.—III. inclusive, and work the exercises recommended there.

The student who has worked through the former part of this work will find that although the forms he may meet with in casts of ornament are more complex, and the gradations of tone more subtle, the general principles of light and shade, and the methods of representing them, will be the same. He has only to put a cast in a flood of light to see that the brightest parts are those turned directly to the rays, and that the others gradually darken in proportion to the angle at which they are turned from the light.

The cast should be fixed upright against a wall, at the

level of the student's eye, and at a distance of about **four** feet. The light should come from above, and if to shine also on the student's board, it should fall from the left; but if the light can be surrounded with a shade and another used to illumine the work, it may be placed on either side.

We will first commence with

The Three Eggs. (Published by D. Brucciani and Co., No. 2,813.)

Step I. (Fig. 57).—Sketch carefully the outline of the rectangular slab. A line passing vertically through the centre of the lowest egg, c, bisects the cast. The horizontal line touching the lower edges of the two upper eggs, a and b, touches also the top of c, and is a trifle above the middle of the cast.

Mark the axes of the eggs, and sketch them in lightly with charcoal. Draw the shadows cast from, and indicate faintly the edges of the shades upon, each egg. Mark the position of the high light upon each. (*See* o in Fig. 57.)

Step II. (Fig. 58).—Shade the background *rather lighter* than it appears. This may be done either as in Fig. 5 or in Fig. 8, or in the following way :—Take a small piece of wash-leather, rub it over a little stumping-chalk, and having tried it first on a piece of scrap paper to make sure there are no lumps adhering, apply it carefully to the drawing.

This method should only be used for the background.

Shade the shadows cast on the background of a depth equal respectively to the *lightest* portion of each.

Step III. (Fig. 58).—Lay on the shades of each, keeping the tones throughout equal to the depth of the reflected light.

The whole is now blocked in, and the shades should bear a *general* resemblance to those on the cast.

To test this, place your drawing beside the cast, and, stepping back some ten feet or so, compare them—a method that may be used frequently until you have obtained the broader masses of their proper *relative* depths.

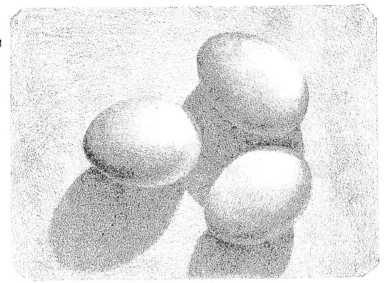

Fig 59.

Fig. 60.

Step IV. (Fig. 59).—Darken the shades near their left edges, and graduate towards the reflected light. (*See* on the Sphere and the Egg.) Lay on a *very light* gradation towards the high light on each egg. The whole of the portion in half-tone is considerably lighter than the reflected light. A very common mistake is to get the latter too bright. If you retire some distance from the cast, you will find that while you are scarcely able to distinguish the reflected light the half-tone remains quite bright.

Step V.—Part of the cast-shadow from A falls on B, and part on C. Be careful to draw these well, and, in shading, to keep their edges sharp.

Darken the cast-shadows on the background near the edges of the eggs. All such deepenings of tone should be gradated.

Here and there the effects of reflection may be seen strongly marked, as, for instance, on the upper portion of C. All such must be shown, but you must be careful *not to break up the broad masses of shade—i.e.*, from a distance the two broad divisions of light and shade should be clearly seen.

The background may be darkened slightly wherever a very light portion—as, for instance, the bright side of the eggs—is to be made prominent.

Recapitulation. (General method for shading casts.)

1.—Sketch the outline of the eggs, their cast-shadows, and their shade.

2.—Lay on the background rather lighter than it appears.

3.—Shade the cast-shadows of an even tint, corresponding to the lightest portion of each.

4.—Add the deepest parts of the shades, and gradate them first towards the reflected light, and then towards the high light.

5.—Deepen the cast-shadows.

6.—Add small gradated tints to the background where required.

Fig. 60 shows the cast lying down. It is not intended

to be drawn as the next exercise, but is merely inserted to show how a cast may be used for several drawings.

The Sphere and Bowl (No. 2,482).

Arrange the cast according to the shadows shown in Fig. 62.

Step I. (Fig. 61).—Draw the rectangular edges of the cast and the three concentric circles, representing respectively the edges of the bowl and the outline of the sphere.

The arrow shows the direction of the rays of light. Consequently, the high lights will be on the sphere at the point marked o, in the bowl at G, and on the edge at J.

The line A B, joining the extreme points of the shadow thrown *within* by the bowl; the line C D, joining the points of the shadow thrown *without* by the bowl; and E F, joining the edges of the shade on the sphere, are at right angles to the direction of the rays of light. The line o G nearly bisects the cast-shadows.

Step II. (Fig. 62).—Draw carefully the cast-shadows and the shade on the sphere.

Shade the background lightly, and the cast-shadows and shades of an even tint equal in depth to their lightest tone. For instance, the *general tone* of the shadow thrown outside by the bowl is darker than the shadow thrown by the sphere, and this in turn darker than that thrown inside by the rim.

In all cases keep the edges of these shadows *well defined.*

Step III. (Fig. 63).—Shade the rim of the bowl, which is slightly darker than the background. Add the darkest part of the shade on the sphere, and gradate towards the right edge.

Gradate its half-tone towards the high light.

Step IV.—Gradate the half-tone on the bowl to its high light at G. The *whole tone* is lighter than the background.

With a piece of bread lighten the chalk along the extreme left edge of the bowl at J, so as to leave its high light.

Step V.—Darken the shadows where required. The

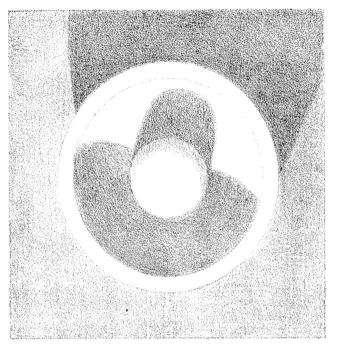

Fig 62.

Fig. 61.

shadow within the bowl cast by the edge will be darkest where it meets the half-tone, and along the extreme left edge—*i.e.*, along the rim.

That is, the central part of the shadow is lightest, for it is lit up by reflected light. (Compare with the inside of the neck of the vase, Fig. 47.)

Similarly, the shadow of the sphere will be lightest towards the centre. In both cases a gradation should be laid over the whole tone from the centre to the edges.

The shadow thrown outside by the bowl will be darkest near the rim and along its lowest edge.

The Pomegranates (Fig. 64).

The rounded forms met with in casts of ornament are seldom of so simple a character as the egg and sphere. A good introduction to these more complex shapes can be found in fruits of varied surface, as the pomegranate.

A little pipe-clay loosened by hot water, and brushed lightly over the fruit, will give them a good cast-like appearance. In the present case, the pomegranates were then suspended by a white cord from a peg, which was thrust through a sheet of cardboard for background.

The light is not from above; the shadow is therefore not so agreeable as it would have been had the light been placed differently.

In shading these, draw carefully the cast-shadows and the exact shape of each piece of shade on the surface of the pomegranates. Lay on the broad masses first : that is to say, those most apparent from a distance. Then, from close at hand, shade the lighter gradated shades.

As there are several projections on each fruit, so there will be several high lights.

The Lily Leaf (No. 2,502).

Leaves form such an important element of many ornamental casts, that one cannot be too careful in giving them their true character. For this purpose nothing is a

better preparation than such a cast as that now before us (Fig. 65).

The light should fall from the left and from above. The most difficult part to be shaded will be found to be within the shadow cast by the left edge of the leaf over the surface.

Step I. (Fig. 65).—Draw the rectangular edge of the cast and the outline of the leaf.

Sketch carefully the cast-shadow thrown by the right edge. Mark the veins on the right.

Now, since the surface of the leaf is cut up by grooves running from the central rib towards the sides, the shadow, thrown by the left edge of the leaf, will be curved in obedience to these variations of surface.

It is most important to draw the outline of this shade correctly, for without adding gradations, this will show the character of the leaf—a quality far more important than mere finish. Draw the small patches of shadow scattered about the leaf.

Step II. (Fig. 65).—Lay both shadows and shades of a depth equal to the lightest portion of each respectively. Remember to keep the edge of the cast-shadows clear, but the edge of the shade less decided. Thus c d is not so sharp in outline as a b.

Step III. (Fig. 66).—Darken the inside shadows from the central rib to the edge of the shadow a b.

Reflection lights up the inside of the leaf. Therefore (as in the similar curved surfaces of cylinder and cone) the darkest portion will be found near the edge of the shade, at c d. Add this, and gradate slightly towards the central rib; and then *very slightly* from c d towards the left.

Step IV.—Using a smaller stump and little chalk, shade the light gradations from the ribs marked on the light right-hand portion of the leaf, and then those within the shaded portion. The extreme left-hand *thickness* of the leaf is turned directly to the light, and is, therefore, bright. This may be shown by wiping out portions with bread, or by

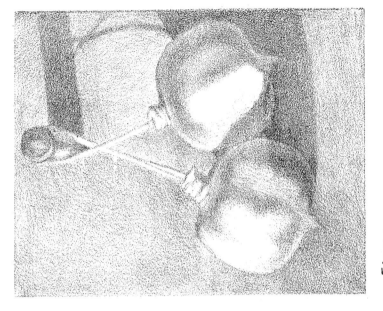

Fig. 64.

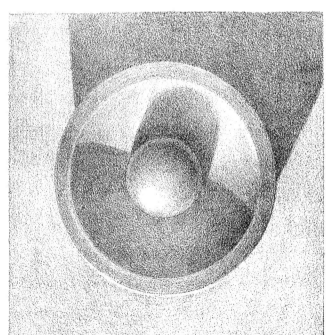

Fig. 63.

bringing the background to within a short distance of the shade on the leaf. (The rim is not *white* in every part.)

Step V.—Lay on all the minute gradations you can see. For this purpose the stump should be almost entirely cleared of chalk. Darken the outside cast-shadow where required, and add a dark line of shade along the lowest left-hand edge of the leaf.

CHAPTER X.

THE APPLES ; TIME-TEST SHADING FROM THE CAST.

OUR next cast contains leaves of a complex character, and apples, whose surfaces are more varied than spheres. The former lessons on the pomegranate and lily leaf will have anticipated many of its difficulties.

Step I. (Fig. 67).—Draw the rectangular edges of the cast. Fix the points A, B, D, E, F, G, and draw lines from each. These will represent the ways in which the charcoal stick should be held before the eye in deciding the direction of the blocking-in lines.

Sketch in lightly the lines K L and M N ; then draw the apples themselves, and block the shapes of the leaves. Beginning with A, and so on to B, D, and F, make the outlines as correct as possible.

Step II.—Draw the shapes of all the cast-shadows and shades. Make, in the corner of your paper, a small pencil sketch of the cast, and, deciding on the darkest portion, mark it with the figure 1. It will lie between the apples. Proceed to find the next darkest tone, and mark it 2, and so on through 3, 4, &c. A drawing as large as Fig. 67 would be of ample size.

Step III. (Fig. 68).—With this sketch before you, lay on first the background of a light tint, and then, beginning with the darkest shadow, 1, shade through all the numbers, 2, 3,

4, &c. In all cases lay these tones equal to their lightest portion, so that the drawing appears as in Fig. 68.

Step IV. (Fig. 69).—The shadows and shades are now blocked in throughout, and you may begin to add the necessary gradations.

Begin with the leaf A, where you will find enough to tax all your care and skill. As it would have been impossible to show all its minute variations of light and shade on the small drawing, a special study has been drawn (Figs. 71 and 72).

Draw carefully, as in Fig. 71, all the shades in the leaf; the three most important are already there. After drawing the veins, proceed to finish as you did with the lily leaf. Consideration of the two drawings (Figs. 71 and 72) will render further explanation unnecessary.

Be careful, above all, not to get the tones too strong. To guard against this, from time to time place your shading beside the cast, and view both from a distance.

The other leaves should be finished in a similar fashion.

Step V.—The Apples.—One of these (the upper) has been shaded alone (Fig. 78). The body is not quite spherical, and its outline should be carefully drawn. It is, in fact, the attention paid to these small differences that distinguishes good from indifferent work.

The eye of the apple lies in a small hollow, and should be shaded, with the high light standing on both sides of it.

A strong reflected light from the lower apple is seen in the shade of the apple before us, but you must be careful not to let this grow as light as the portion in half-tone. This latter gradates on all sides towards the high light. (Compare with the sphere.)

When the shading of a cast is complete, *no hard outline* should appear. This should be formed by bringing adjacent tones to a clear edge. Thus with the apple under consideration: its high light is brighter than the tone of the neighbouring leaf to the left. Its edge here will, therefore, be expressed by bringing the tone of the leaf accurately to the

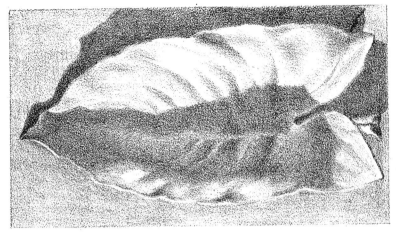

Fig. 66.

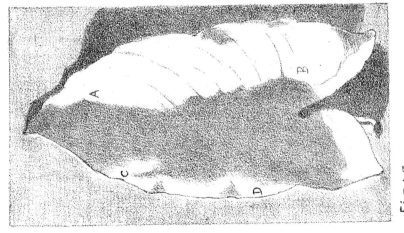

Fig. 65.

faintly-sketched outline. Just below the high light, the leaf is *lighter* than the apple ; the tone of the latter is, therefore, worked carefully up to the outline, and so on.

By this means, all hard outlines are omitted, and the completed apple stands amidst its surrounding leaves, as in Fig. 70.

Samuel Prout, speaking of this point in reference to light and shade in landscape drawing, says: " Positive forms and harsh cutting outlines are contrary to truth and beauty, and should never force themselves on the eye, except in small proportion to produce solidity." This applies equally to cast shading.

Time-Test—Shading from the Cast.

In the second grade, the time allowed will be decided by the inspector according to the difficulty of the cast.

In the third grade examination four hours are given. The cast of apples just drawn is of average difficulty for the latter.

The method recommended for either examination is the same. First make a *careful and correct outline* in charcoal of the whole. Then indicate, by numbering, the depths of light and shade, upon a pencil sketch that may be made in the corner of your paper, or, if you prefer it, by charcoal on the drawing itself.

Next block in the shadows of their average depth. This is very important, for by expressing these truly you obtain breadth of effect. If you have worked expeditiously, you should have at least one hour left, in which you might work up completely a leaf or an apple (Figs. 70 and 72), to show how you would have proceeded to finish the cast.

You might, with practice, complete even more, but it is advisable not to scamp your work.

The Egg-plant (No. 484 B).

The deep under-cutting of this cast—a portion from the frieze of the famous Ghiberti Gates—makes it especially useful for showing light and shade.

It has been selected here as a specimen of the more advanced work required to be sent in for the Art Class Teachers' Certificate.

The blocking of the shades and shadows is shown in Fig. 75, and the completed drawing in Fig. 76. It should be shaded after the same method as the last cast.

There are a few fresh features that may need explanation.

1. *The Leaves.*—Those along the upper row are flat, and it is somewhat difficult to determine their exact amount of shade. A little consideration will show that since they lie parallel to, and almost flush with, the background, they must be mainly of the same tone as the background.

Figs. 73 and 74 show the leaves in process, and complete. First shade them flat as in Fig. 73, and sketch upon them lightly the shape of the shaded portions. Then, with the greatest care, put on the minute gradations from right to left. The left edge of the leaves is bright, and the right casts a thin shadow. Moreover, as the right edges are curved a little, reflected light from the background and surrounding forms will cause the deepest part of the small shade to stand away from the shadow.

The other leaves are not so difficult, as their light and shade are more distinct.

2. *The Fluted Border.*—We will take the lower one. Its upper rim is turned to the light, and is consequently bright. Shade the fluted portion as shown, *i.e.*, of the depth of the lightest portion (Fig. 75). Next add the two gradations : the first from the upper edge towards the centre (along which the high light runs) ; the second from the high light towards the lower edge. Compare the incomplete and complete drawings.

It would be as well to mark lightly the position of the high light along the ridge before adding these gradations.

We have throughout insisted upon the importance of looking at a group or a cast *as a wh le*. It is a fundamental mistake to take each part, and to consider it without

relation to its depth of tone *to all other parts :* which it is impossible to do if you proceed as shown in this work.

Again quoting Samuel Prout (an acknowledged master in chiaroscuro) :—" The excellence of light and shade mainly depends upon breadth. Objects, and therefore the parts of an object, should be treated as a mass ; but to give to each separately its proportion of light and shadow is to form *pictures of parts*—the very opposite of breadth."

And Sir Joshua Reynolds, in his notes on Fresnoy :— " The highest finishing is labour in vain, unless at the same time there be preserved a breadth of light and shadow."

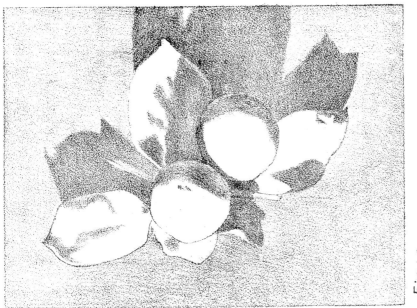

Fig. 67

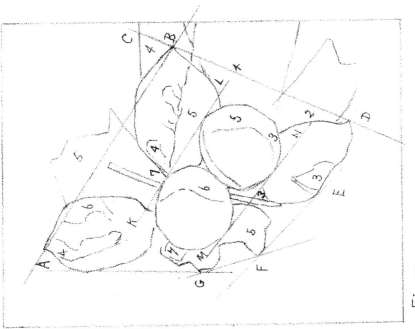

Fig. 68.

APPENDICES.

Cross-hatching.—The great advantage the stump has over either pencil or crayon lies in the rapidity with which shades may be applied and the broad effects produced. But for small, delicate work the point may be used with advantage.

We shall first speak of cross-hatching: a method which, as its name implies, consists in merely placing lines across one another.

If you take any flat surface—as the face of a *cube*—you can draw straight lines across it in an infinite number of directions. They might be parallel to the edges, at right angles to them, or, indeed, at any angle you choose. But, on the rounded surface of a *cylinder*, in one direction only can such straight lines be drawn, *i.e.*, parallel to the axis of the solid.

Lines in other directions must necessarily be curved.

Again, the only straight lines that can be placed on the rounded surface of a *cone* must run from the apex to the base to form in each case the hypotenuse of a right-angled triangle, whose perpendicular side is the axis of the cone. Every other line must necessarily describe a curve.

The *sphere* is curved in every part, and no straight line can be drawn upon it.

In this you have the whole principle of cross-hatching. All flat surfaces—whatever their outline, square, circular, or irregular—should be shaded entirely by straight lines; the cylinder and the cone by straight and curved lines; the sphere by curves alone. That is, *lines should vary in curve and direction according to the surface they are to represent.*

Beautiful examples of this may be seen in the best of the old line engravings.

Materials.—The materials required are a B B pencil or a Contè crayon No. 2, and *rough* paper of any description. The French paper recommended for stumping will suit admirably.

The point of the pencil—there is no need to add "crayon," for these directions apply to both—should be sharpened in a chisel form, and the widest sides used for the broadest masses of shadow. The sharper sides will be found useful for clearing the edges or for the smaller tones.

Preliminary Exercises.—I. Mark out a sheet of French paper into several divisions. In one, draw a number of straight lines as parallel as possible to the other; then carry another set of similar lines across these, but not at right angles. The insterstices will be rhomboidal rather than square (Fig. 77). You have but to carry such lines across in other directions to get a tone of any depth you please. In Fig. 78 such a darkened tone is shown. The pencil should be carried *lightly* across the paper, which is made rough, so that the projections may catch the lead and leave the hollows shining through. Says Hume Nisbet in "Life and Nature Studies":—"Learn to walk over the surface again and again without disturbing or blotching your last tracks; raise no mud, but to the last try to show the paper shining through; lean heavy, and your pencil digs into your paper and leaves furrows which are opaque for ever; skim lightly, and you will grow *dark* without growing black."

II. In another division (Fig. 81) place a number of parallel straight lines, and cross these by curves running not at right angles; cross these in other directions by other curves. This will be the method of shading cylindrical bodies.

III. Draw diverging straight lines, from a point (Fig. 79), and cross these as before by curved lines : this shows the shading of cones.

IV. Draw parallel curves (Fig. 80), and cross these by others : the shading of a sphere.

Flat Tints (continued).—I. Sketch a square, a circle, and a hexagon. · Cover these by straight cross-hatched lines. Shade the circle deeper than the square, but lighter than the hexagon.

II. Rectangles as in Fig. 7 should be drawn, and flat tints laid round them.

The lines should not in any case encroach on the space to be left clear.

Gradations.—I. Flat surfaces (Fig. 9).—Draw a divided rectangle as shown, and fill each division with a flat tint, increasing in depth as the lowest is approached.

Fig. 10.—Still using straight lines, make as even a gradation as you can. Even in the darkest portion the tone should not be a *dead* black.

II. (Fig. 13).—Fill with flat tints as before. Then (Fig. 14) begin in this case in the middle, and, working first to the left and then to the right, leave the crossing lines more open and less numerous as the sides are reached.

Gradations on Curved Surfaces (Fig. 20).—Draw the circle, and cover the whole with curved lines, spreading from the dark point below. Cover these with other curves, gradually decreasing in number and closeness towards the lightest portion.

The Geometrical Models.—In shading models, the steps to be taken are the same as advised for the stumping method.

To make our meaning perfectly clear, we show here the shading of a cylinder.

Step I. (Fig. 84).—Draw the shadow and mark the outline of the shade. Lay the shadow evenly by means of straight lines only where it falls along the flat surface. (If it met a rounded body the lines would be curved, as in the right-hand portion of the shadow.)

These lines may be drawn broad and close without necessarily crossing them.

Step II.—Lay the shade by means of straight lines running down the face of the cylinder (Fig. 84). To show the darker portion of this, cross the shade near the edge by curved lines, by means of which a gradation should be made towards the edge.

Step III.—Mark the high light and gradate the half-tone from the edge of the shade, either by means of straight lines alone growing gradually wider apart, or by such lines lightly crossed.

Step IV.—Gradate the upper circular end by means of straight lines only, for it is a flat surface. Gradate the cast-shadow by similar lines.

After completing the course in model shading, you may attempt the shading of casts; but, of course, unless you are skilful, these will take very much longer than if shaded by the stump.

All the drawings illustrating this work were shaded by the point, but that simply because the stump cannot be applied successfully to the lithographic process. If it could, there would be little hesitation in deciding whether or not to use it.

In short, for chalk shading the stump is freer, bolder, and altogether to be preferred, especially for large masses of shadow and for delicate gradations.

The Pencil or Crayon used with the Stump.—The stump and point are sometimes used together effectively in the following manner:

Flat tints are laid by the stump, and then this tint is gradated by means of lines cross-hatched upon it.

Thus with the cube: first lay the tints as in Fig. 22, then add the gradations from the corners and darken the shadow with the crayon, using, of course, straight lines only.

Again, if you are shading rounded surfaces—as, for example, the sphere—you will first lay the shade flat (Fig. 42), and then by means of curved lines (Fig. 80) add the necessary gradations.

Of course, if you are shading with pencil the stumping-

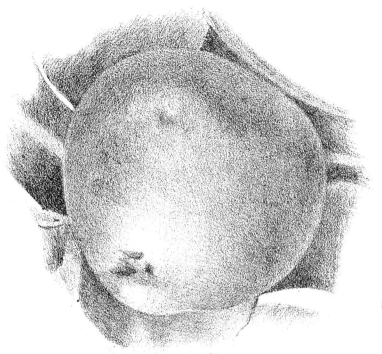

Fig. 70.

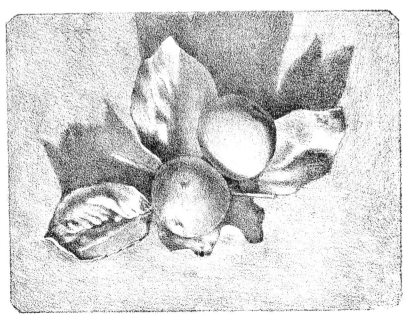

Fig. 69.

chalk must not be used at all. In such case take a piece of rough paper, and rub the B B pencil over it until there is a good deposit of lead. Then with a stump that has not been used for chalk shading lay the required flat tints. These should be cross-hatched with the pencil only.

Neither can the crayon be used for hatching over pencil shades. The great drawback of this method is that the lines are apt to appear too black over the greyer tint.

II.—SEPIA AND MONOTINT PAINTING.

Shading with the stump forms a capital introduction to water-colour painting in monotone, as there is very much in common between the two methods. In both, broad tints can be laid, and gradations added without unnecessary use of the point—of the crayon in one case, of the brush in the other. In both, stippling and such like " niggling " methods are to be used only where absolutely necessary, the skill of the worker being shown rather by the breadth than the finish of the drawing.

Having selected your colour—sepia, Indian ink, or blue-black, as the case may be—grind it up in three or four saucers, the colour increasing in depth so that the first may be light, the second darker, and so on. Two glasses of clean water are needed : the one for freeing brushes from colour, the other for washing over the tints.

Materials.—In addition to the colour, you will require large sable brushes and Whatman's paper ;—for large, bold work (such as groups of models), the rough double-elephant ; for more refined, the " Not."

To Stretch the Paper.—The paper must be stretched perfectly flat, otherwise the washing will cause it to rise in ridges, in the hollows between which the colour will collect, leaving the projections comparatively free.

Soak the paper thoroughly in perfectly clear water, in which, indeed, it may be entirely immersed for two or three hours.

Then take the paper, lay it flat on the board, and turn up

the edges all round to the depth of about an inch. With a little strong paste cover the underside of this margin, lay the edges flat, and with a clean cloth press the paper firmly to the board, squeezing the superfluous water from the centre towards the sides. The edges should then be pressed down with special care.

Leave the board in a slightly sloping position to dry, when it will be found perfectly smooth.

Method.—The principles of light and shade are the same, so that you have merely to learn how to *wash* in flat tints and gradations. For this purpose the exercises given for stump shading will be found exceedingly useful.

Take your board with the stretched paper, and incline it at about an angle of 45°. Place your glasses of clean water handy, and the saucers of colour arranged in the order of depth of tone (1, 2, 3, &c.).

Flat Tints.—Divide your paper into two equal parts, in one of which draw a large rectangle, in the other an ellipse.

(1) With a large brush and clean water wash over the rectangle and the ellipse, being careful to wash *exactly* to the outlines, so that only the rectangular and elliptical spaces are wet.

(2) When the paper is so far dry that you can see no water *glistening* on the surface when turned to the light, but still wet enough to feel damp, with a brush, filled from any one of the saucers, begin at the top left-hand corner of the rectangle, and carry the tint carefully towards the right.

The colour will spread evenly, and you will find no difficulty in leading the colour down to the lower edge. If necessary, you may replenish your brush before reaching the end.

(3) As you approach the very edge, clear your brush of paint, and with it, perfectly clean and dry, take up all the superfluous paint, that would otherwise collect in a ridge.

Colour the ellipse in the same way.

When *perfectly dry*, wash the whole lightly with clean

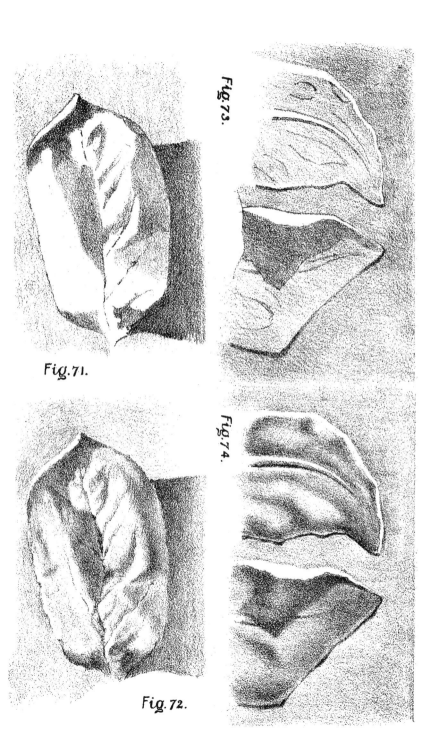

Fig.71.

Fig.72.

Fig.73.

Fig.74.

water as before, and when again the water has soaked in sufficiently, put another wash over the first.

For the sake of practice, it would be well to slope your board at times, so that the right- or left-hand edge or one of the corners may be uppermost.

I. Gradations.—Stretch another sheet, and divide it into four parts.

(1) Draw in the first a divided rectangle (Fig. 9). The lines may be sketched in black-lead.

Wash over the whole rectangle with clean water. At the proper moment, with a brush charged with colour from the first saucer, fill the top rectangle. As the colour runs to the lower edge, clear it with a dry brush, and then immediately filling the brush from the second saucer, colour the second rectangle as you did the first. Similarly colour the other rectangles with the next two tints, when you will find you have a gradation.

(2) Fig. 10.—Wash the rectangle with water, and proceed as in 1; but with this difference: after you have washed in the first tint as far as you think right by comparing with the divided rectangle, do not clear the lower edge, but add the second tint to it immediately. Add the third and fourth tints in a similar fashion.

(By turning your board upside down, and proceeding as in (5), you may obtain this gradation in another way.)

(3) Fig. 11.—Divide the sector as shown, and proceed as in 1, but with this exception: that you begin with the darkest tint.

(4) Fig. 12.—As in (2) begin with the darkest, and then by judgment add the lighter tints in their order.

(5) *Another Method.*—This last gradation (and by reversing the board, the second (2) also) may be thus obtained.

Begin with the darkest tint, and when you have carried it far enough, *dip* the brush as it is into the clean water, and with the colour thus diluted lead the tint down. After carrying the tint a little distance, dip the brush once more

into the water, and so on. This is the method generally adopted, and after practising gradations by means of the separate tints, you should as soon as possible proceed to use it.

You will find the first method, however, especially useful when the gradation is from light to dark, as in the next exercise.

II. Gradations (continued).—(6) Fig. 13.—After dividing the sheet as shown, slope the board so that the left side may be uppermost. After washing with water, fill the rectangle on the extreme left (which will now, of course, be uppermost) with the lightest tint, as recommended in 1. Then add the second ; then the third.

The gradation now runs from dark to light. You may, therefore, use either the method shown in 4 or 5.

(7) Fig. 14.—Gradate this without using the dividing lines.

(8) Figs. 15 and 16.—In this case the board should be sloped, so that the *lowest left-hand corner* may be uppermost.

The method needs no explanation.

III. Gradations over Tints (Figs. 17 and 18).—These present no difficulty whatever.

After washing in the flat tint, let it get *thoroughly dry*, and then add the gradations as above.

You may now proceed to the models.

For the sake of clearness, we show the method of painting a cube. Objects with rounded surfaces will generally show gradations in two directions, as Fig. 14. If, therefore, the exercises recommended have been carefully worked, these present no new difficulty.

The Cube (Fig. 23).—No part is perfectly white, though the front edges of the top face are nearly so.

Decide the number of broad tints you can see on the model, the background, and the ground-plane.

There are six, the darkest being the cast-shadow ; the next in tone the left-hand perpendicular face ; next the

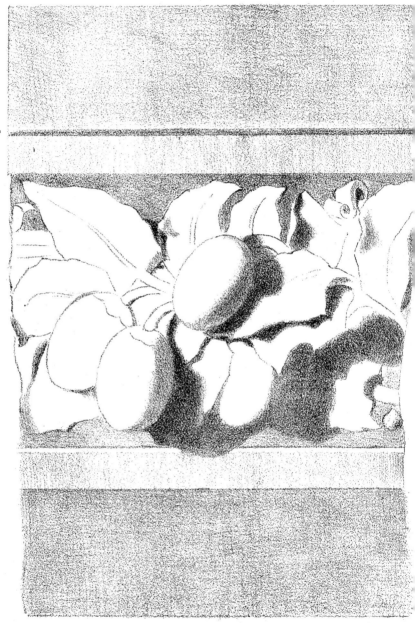

Fig. 75.

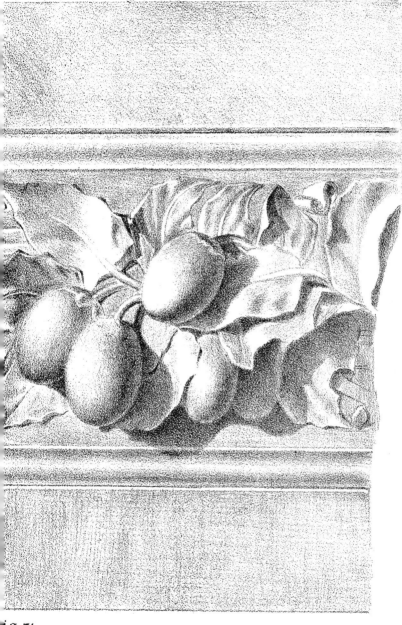

ig. 76.

background, then the right-hand face ; the ground-plane ; and lastly the top face (Fig. 22).

Now in one saucer (or in one compartment of a grinding dish) prepare a tint equal in depth to that of the top face. You may test the depth by colouring a strip of paper with the wash, and comparing it when dry with the tone.

Grind another tint of such a depth that *when washed over the first* the two will give a tone equal to that of the next darkest—the ground-plane. You can test the depth by using the strip of paper which you have already coloured with the first tint.

Proceed similarly to obtain the remaining four tints.

(1) Draw in pencil the cube and its shadow. Wash the sheet with water, and then cover the whole with the lightest tint.

(2) *When dry*, wash again with water, with the exception of the top face, and then cover the whole with the second tint.

(3) Then washing with clean water all but the top face and ground-plane, cover with the third tint; and so on through the others.

The shading will then appear as in Fig. 22.

Of course, these tones might have been obtained by taking so many different depths of colours, and washing them in at once. Thus, suppose the whole background only to have been laid. You add now, for instance, the right-hand face alone, at once of its proper depth. Beside this you next lay the darker perpendicular face alone ; and so on.

But you would find it impossible to make such tones *meet* at an edge without producing a hard line ; whereas, there is much less chance of this happening if you wash *over* a tint with another.

As it is, by the better method hard lines frequently appear. It is well, therefore, at each sitting to wash over the *whole* drawing with clean water to soften such edges. When this is dry you would then simply wash with water those parts that are to receive a tint, and proceed as usual.

(4) But the gradations are to be added to our cube.

You have merely to slope the board so that the gradation shall run, in each case, from top to bottom, and add the small gradations according to previous directions.

The other models can be shaded similarly if you first wash in the broad flat tints, and add the gradations as above.

Cast-shading.—Wash over the whole with the lightest *general* tint, which in most cases will be that of the background. The tones next in depth should be added, and so on. The first stage will therefore be represented by Fig. 68.

In all cases where a dark portion lies in *contact* with a lighter—as, for instance, in Fig. 59 : the reflected light with the cast-shadow—you should, in washing in the tone of the lighter, carry it also over the darker.

The high lights, if white, may be removed with a knife, and the delicate gradations from them added. In doing this, be careful that you end with no hard lines on the surface.

Thus in Fig. 69, when you come to add the gradation on the top apple from the high light to the shade, carry the tone also over the shaded portion ; but if this is already of its proper depth, carry the gradation across the shade *with clean water only.*

To Darken Tones.—Occasionally you will find unevenness in your work. Spots of lighter colour will appear here and there, which it would be almost impossible to smooth with washes.

In these cases, with a smaller brush lay on the colour in strokes by cross-hatching, or even, in delicate cases, with mere points.

By no means resort to this stippling if you can possibly avoid it, for the patches are apt, after all your care, to look dead.

To Lighten Tones.—Take a rather hard brush and wash over the part to be lightened with clean water. If it is to be considerably lightened, hold the brush perpendicularly, then,

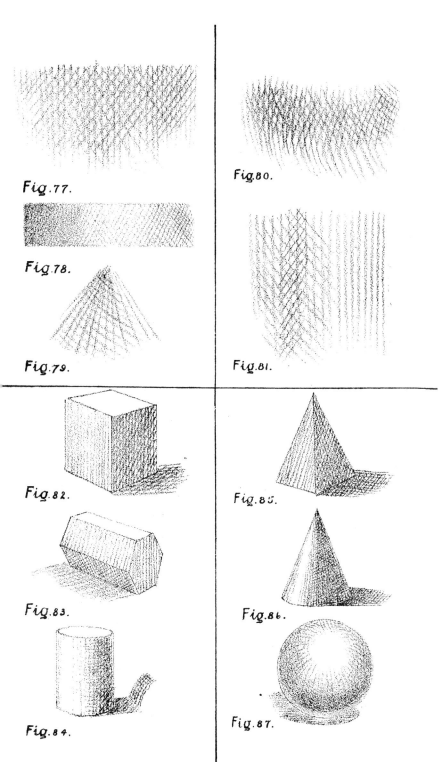

Fig. 77.

Fig. 78.

Fig. 79.

Fig. 80.

Fig. 81.

Fig. 82.

Fig. 83.

Fig. 84.

Fig. 85.

Fig. 86.

Fig. 87.

twisting it between the fingers, *scrub* up, as it were, the colour, which may then be removed by blotting-paper or by dabbing it with a dry cloth.

By this means you may get rid almost entirely of the colour ; but you should be careful not to use this method too freely, as it is apt to destroy the surface of the paper.

For high lights—such, for instance, as the rim of the bowl in Fig. 71—it is sometimes advisable to cover the whole as though there were no high light, and then with a sharp knife scrape off the colour where necessary.

Sepia-painting, then, speaking generally, is the reversal of the stump method, as far as the first blocking-in of tones is concerned. For, for monotint painting, the numbering in Figs. 55 and 67 should be completely reversed, as we have seen above.

But, this apart, there is so much in common between the two processes of stumping and washing that they may be well considered as different expressions of the same.

To Transfer Outlines.—You may at times wish to make finished drawings of groups or casts. If these are outlined on the paper intended for the completed work, the lines made by the charcoal are apt to assert themselves, for they cannot always be completely dusted away. The paper, too, may in other ways become unsightly.

It is usual, then, to transfer the drawing to another sheet. Since the first drawing will be destroyed, any common paper may be used for the outline.

First rub the back of the paper on which the outline has been drawn with a soft black-lead pencil. When covered, rub off the superfluous lead as far as possible with a cloth—until, indeed, no more will come off readily. Then lay the blackened side on the paper upon which the finished shading is to be made, and after pinning the corners down securely, go over the outline with a pencil.

You should not press too heavily, or you will dig grooves in the paper beneath, which will appear white lines in your subsequent shading.

From time to time lift up one of the corners to see whether the outline is transferring.

When finished, remove the upper drawing and go over the other lightly with a pencil to secure the outline, but so carefully that the drawing is barely visible. The small quantity of pencil thus used will not interfere with the chalk afterwards used in shading.

THE END.